Everyone Can Draw
DINOSAURS

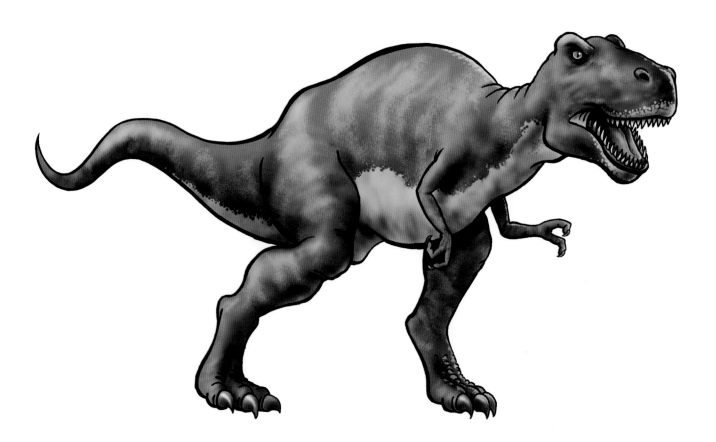

by Peter Gray

WINDMILL
BOOKS

New York

Published in 2013 by Windmill Books, An Imprint of Rosen Publishing
29 East 21st Street, New York, NY 10010

First Edition

Project Managers: Joe Harris and Anna Brett
Editor: Deborah Kespert
Illustrations: Peter Gray
Design: Picnic

Library of Congress Cataloging-in-Publication Data

Gray, Peter, 1969–
 Everyone can draw dinosaurs / by Peter Gray.
 p. cm. — (Everyone can draw)
 Includes index.
 ISBN 978-1-61533-509-1 (library binding)
 1. Dinosaurs in art. 2. Drawing—Technique. I. Title.
 NC825.D56G73 2013
 743.6—dc23
 2012003436

Printed in China

SL002242US

CPSIA Compliance Information: Batch # AS2102WM: For further information,
contact Windmill Books, New York, New York at 1-866-478-0556

CONTENTS

You Will Need...

Every artist needs essential drawing tools including pencils, pens, a ruler, paints, and paper. As you become more experienced, you can add materials such as ink pens, gouache paints, or pastel crayons. They will help you to develop your own favorite style.

PENCILS
Pencils come with different weights of lead. Hard lead pencils (#2 ½ to #4) are useful for drawing precise, fine lines. Soft lead pencils (#1 to #2) work well for shading and softer lines.

MARKER PENS
Before coloring in, it's a good idea to go over your pencil outline. A marker pen is perfect for this and you can use a thick or thin one depending on the effect you want to create.

PAPER
You can use different types of paper for different jobs. When practicing shapes and lines, a rough sketch paper is practical. For final colored-up drawings, a smooth plain paper works well.

RULER
For technical drawings, a ruler really helps. It will allow you to make your lines straight and angles accurate.

ERASER
From time to time, you'll make mistakes or need to remove guidelines. That's where an eraser comes in handy. Don't worry if you make mistakes. Everybody does!

PAINTS

There are many different kinds of paints you can experiment with, but poster paints and watercolors are an excellent starting point. You could also try gouache, which will give you more solid tones.

FELT-TIP PENS

Felt-tips are perfect for coloring drawings that need bold, bright colors. They work especially well for cartoons.

ART IN ACTION

Take a look at the examples below to see how to get the best out of using different pens, brushes, and paints.

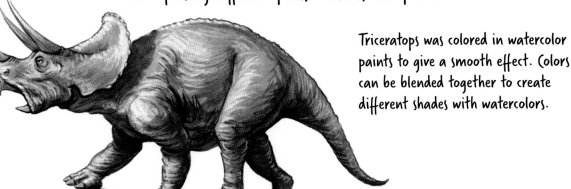

Triceratops was colored in watercolor paints to give a smooth effect. Colors can be blended together to create different shades with watercolors.

Felt-tip pens were used to color Dimetrodon, making it look dramatic. The outline was done with a fine, black marker pen.

Ready, Set, Go!

Are you crazy about dinosaurs? Then this book is perfect for you because it's packed full of ideas and inspiration to help you draw T. rex, Velociraptor, Ankylosaurus, and many more. Whether you want to improve your skills or pick up some tips, just dive in!

STYLES

You'll find two different styles of art in this book. There are realistic drawings where your goal is to make the picture look natural and there are also fun cartoon drawings.

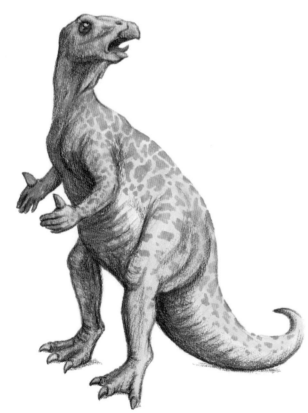

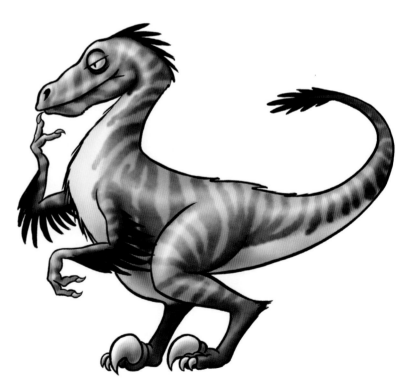

REALISTIC STYLE
Iguanodon is drawn and colored in a realistic style with watercolor paints. Paying attention to detail and looking for references to copy helps with realistic drawings.

CARTOON STYLE
Velociraptor is drawn and colored in a cartoon style. The features are exaggerated and there is a thick black outline. Cartoon drawings allow you to experiment with shapes and colors.

FOLLOW THE LINES

Build up your picture step-by-step by looking at the color of each stroke. Red strokes show you the lines you need to draw and black strokes show what you have already drawn. All the lines will be red in the first step. After that only the new lines will be in red.

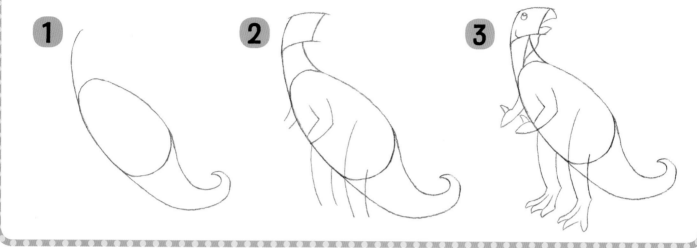

COLOR MAGIC

When you color your drawings, you instantly bring them to life. You can work with colors that go well together and also those that contrast.

No one knows what colors dinosaurs were so feel free to experiment. We have contrasted blue and green to make Archaeopteryx look dramatic.

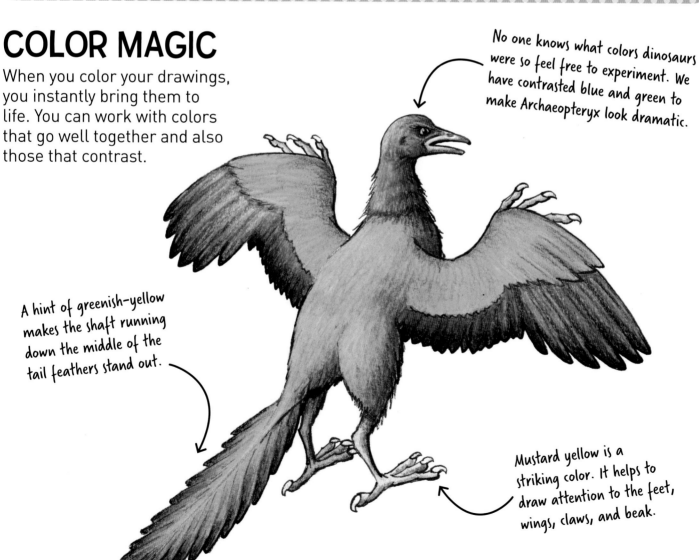

A hint of greenish-yellow makes the shaft running down the middle of the tail feathers stand out.

Mustard yellow is a striking color. It helps to draw attention to the feet, wings, claws, and beak.

Tyrannosaurus Rex

Follow the steps to draw the most terrifying dinosaur of them all, the bone-crunching T. rex. Work hard at getting the shape of the body right with all its knobbly bumps and curves.

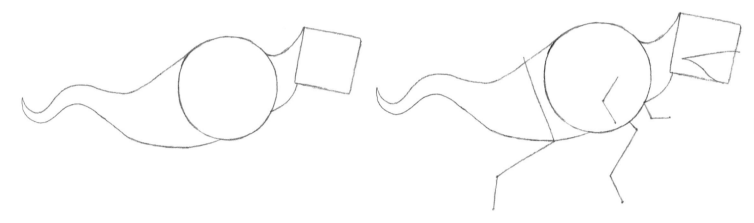

1 Draw a big circle for the body and work outward to shape the neck and tail. Notice how the thick tail tapers to a point. A box shape forms T. rex's head.

2 The legs and arms are tricky so start with stick drawings. Copy the picture, carefully paying attention to the line lengths and angles. Then shape the mouth.

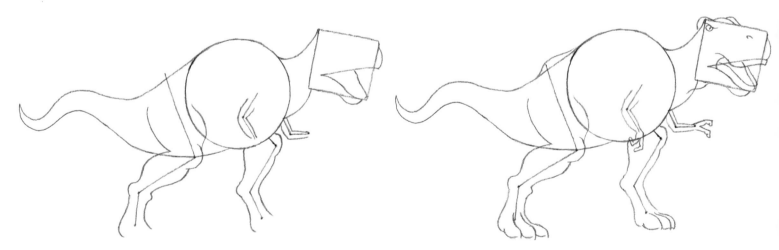

3 Now work on the shape of the legs. Make them chunky at the thighs and include bulging muscles. The arms should be short and skinny. Develop the mouth further.

4 Finally add the details. Work on the face, including the two bumps at the top of the head and add a guideline for the teeth. Shape the feet, hands, and bumpy back.

5 Use a thick pen to outline the bulky body and color in the beast. Heavy shading, especially around the limbs and under the eyes, adds a menacing effect.

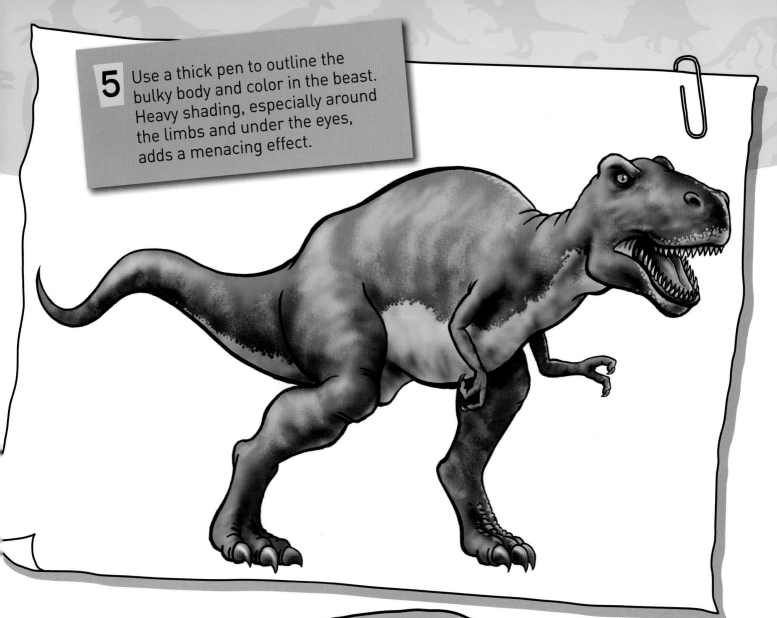

TOP TIPS

Check out these tips on how to finish the sharp teeth and claws!

Your T. rex needs lots and lots of teeth to munch its dinner. Work with a fine pen to draw them accurately and to provide a contrast to the heavier body outline.

When drawing the claws, make them long and curved to show how they can grab prey. Blend orange into cream to make them look really grubby!

Velociraptor

Velociraptor may not have been a very large dinosaur, but it sure was vicious! Try drawing this cartoon creation, including those lethal hind claws.

1 Start off with a crescent shape for the body and tail, swooping around to make the curves. Draw three swift strokes to form the pointed head.

2 Keep the contrast between the curves and straight lines as you outline the legs and arms. Work more on the shape of the head and develop the end of the tail.

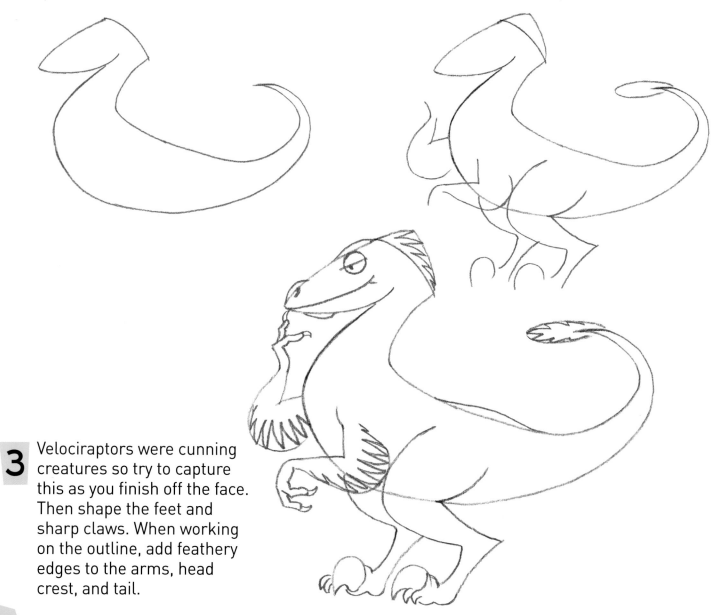

3 Velociraptors were cunning creatures so try to capture this as you finish off the face. Then shape the feet and sharp claws. When working on the outline, add feathery edges to the arms, head crest, and tail.

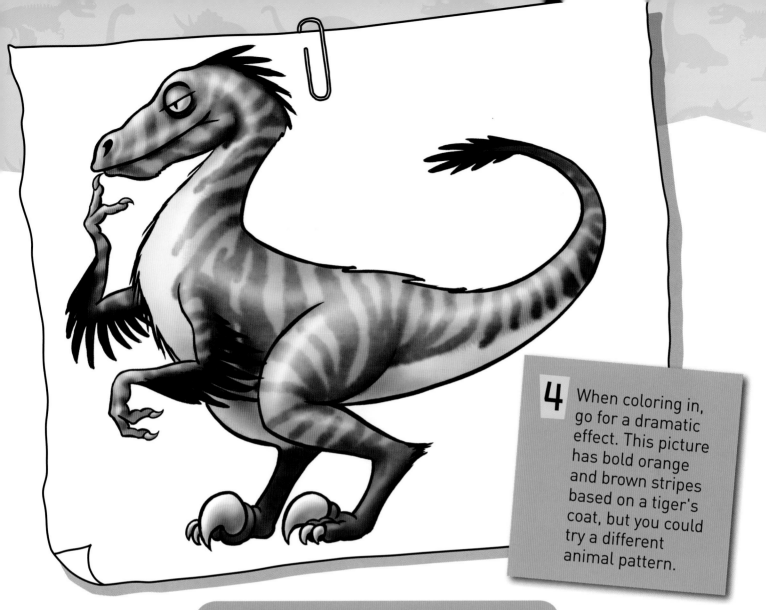

4 When coloring in, go for a dramatic effect. This picture has bold orange and brown stripes based on a tiger's coat, but you could try a different animal pattern.

CARTOON CORNER

Adapt your drawing to create a hatching baby Velociraptor.

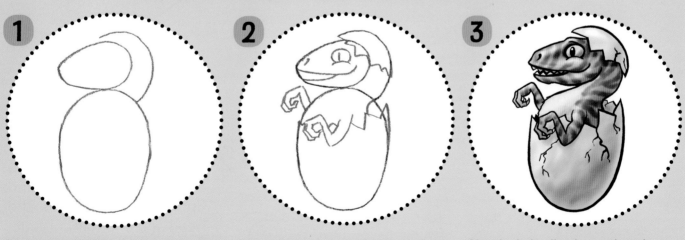

1 Draw an upright oval for the egg and a more pointed one on its side for the dino's head. Join them with a curve.

2 Work on the the cute face and shape the grasping arms. Add jagged lines to show where the egg has cracked.

3 Give the baby dino its teeth and color it in as before. Choose a shade for the egg and add fine crack lines.

Iguanodon

Iguanodon was a large plant-eating dinosaur with two unusual thumb spikes. Here, you are working in a realistic style. Give the dinosaur a mottled skin to show that it is a reptile.

1 Begin with a tilted egg shape for the body. Then shape the thick swishing tail. Remember to curl it at the end. A long, curved line starts to form the neck.

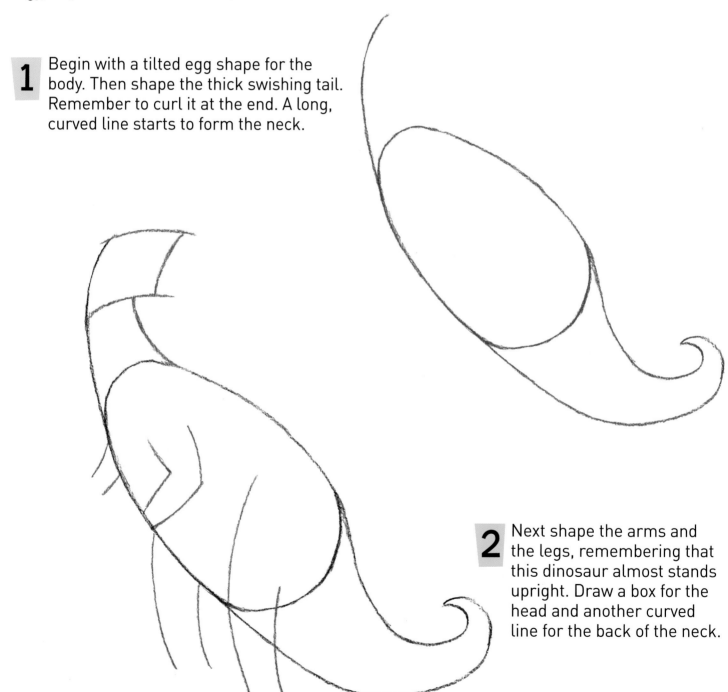

2 Next shape the arms and the legs, remembering that this dinosaur almost stands upright. Draw a box for the head and another curved line for the back of the neck.

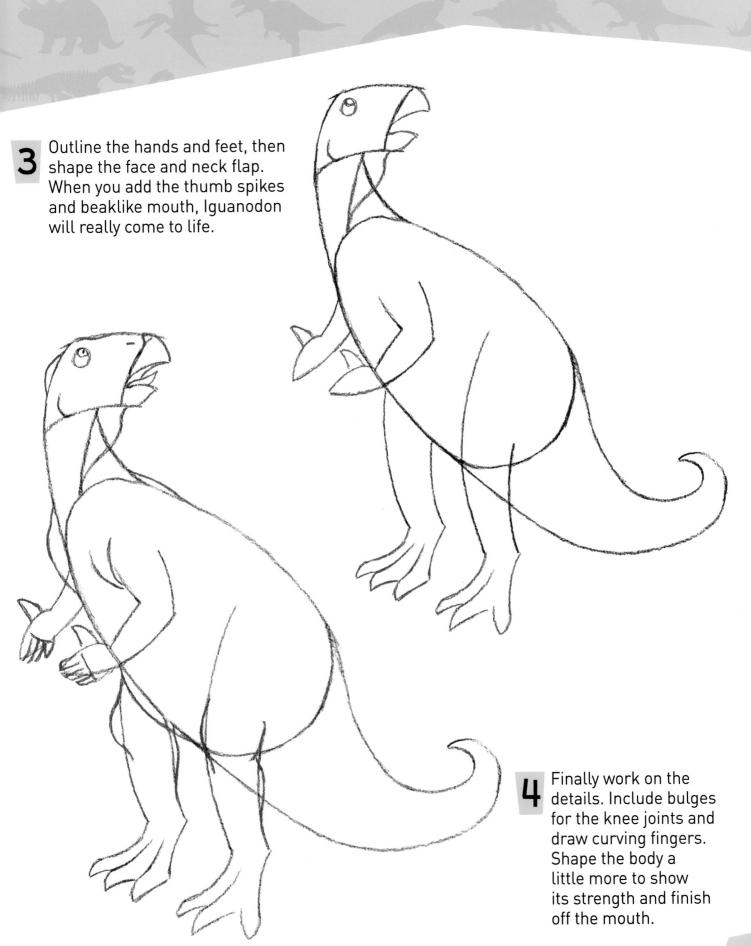

3 Outline the hands and feet, then shape the face and neck flap. When you add the thumb spikes and beaklike mouth, Iguanodon will really come to life.

4 Finally work on the details. Include bulges for the knee joints and draw curving fingers. Shape the body a little more to show its strength and finish off the mouth.

13

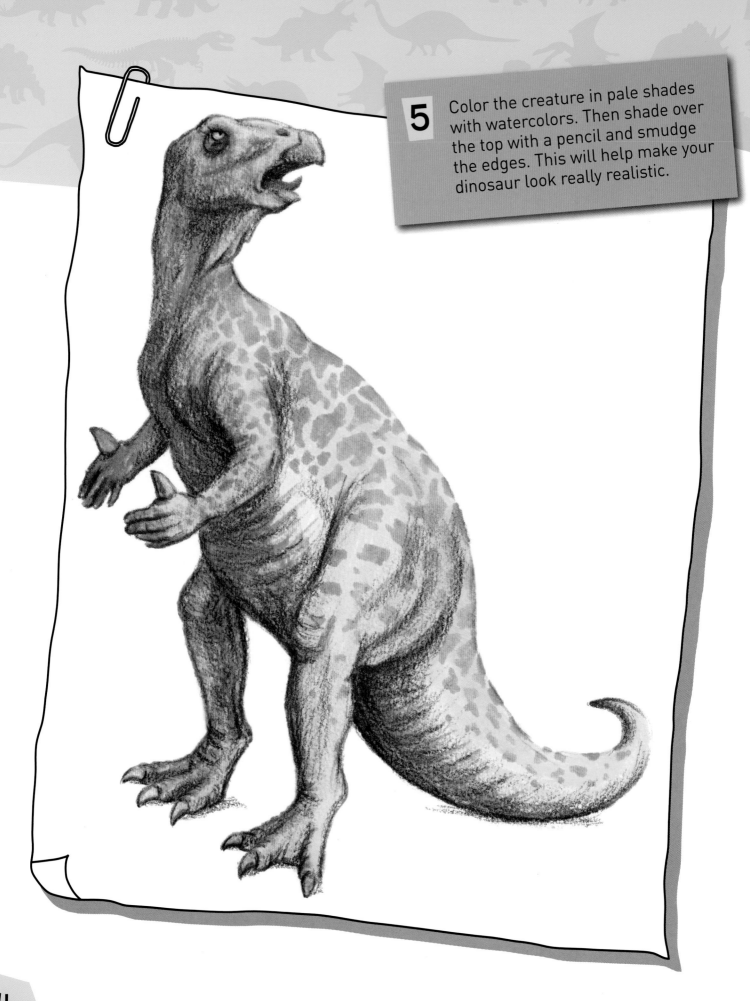

5 Color the creature in pale shades with watercolors. Then shade over the top with a pencil and smudge the edges. This will help make your dinosaur look really realistic.

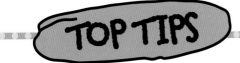

TOP TIPS

By paying attention to the details, you can give the image more impact.

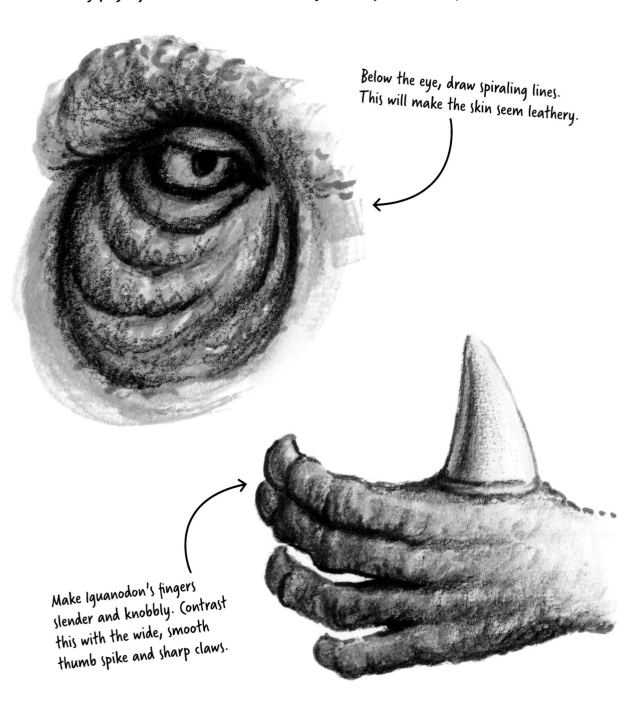

Below the eye, draw spiraling lines. This will make the skin seem leathery.

Make Iguanodon's fingers slender and knobbly. Contrast this with the wide, smooth thumb spike and sharp claws.

Brachiosaurus

This cartoon Brachiosaurus is really easy to draw. What's more, no one really knows what color dinosaurs were, so you can choose any colors you want to finish it off!

1 First draw a long banana shape. Around this, add two bulging curves. These form the dinosaur's body, tail, and long neck.

2 Next plot out the wide thighs with two U-shaped curves. Finish off the tail and shape the tiny head at the top of the neck.

3 Now add the lower legs. Flatten out the ends to make funny oversized feet and draw the toes. In contrast, the head should be tiny with lots of personality. When erasing the guidelines, be sure to leave the domed head crest.

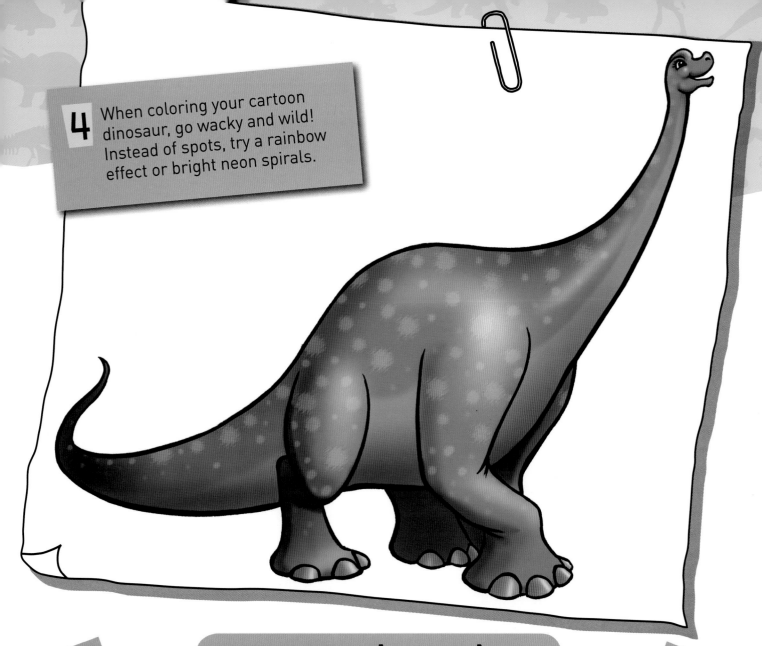

4 When coloring your cartoon dinosaur, go wacky and wild! Instead of spots, try a rainbow effect or bright neon spirals.

CARTOON CORNER

How about giving your dinosaur a snack to chew on or a footprint trail?

1

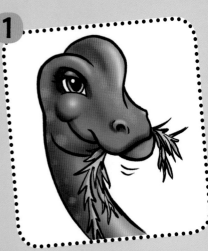

Brachiosaurus munched on leaves and twigs from the treetops, reaching them with its long neck. When you draw its snack, make it look like a plant from Jurassic times!

Brachiosaurus had wide feet. Try using a photo of an elephant's footprint for reference to show a dusty trail on the ground.

2

17

Triceratops

With its pointed horns and giant neck plate, Triceratops looked fierce, but this gentle giant only munched plants. Follow the steps to capture its bulky, leathery frame.

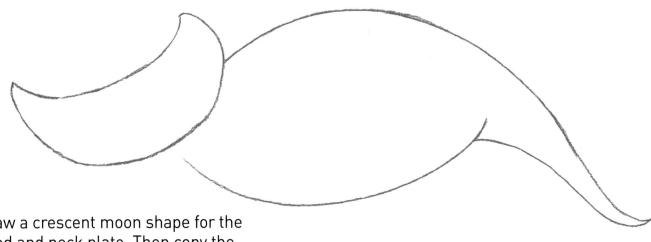

1 Draw a crescent moon shape for the head and neck plate. Then copy the rest of the picture to form the body and tail. Make the the head quite big in relation to the body.

2 Develop the head further by outlining the nose horn and the beak-shaped mouth. Don't forget to add the eye. A series of curved lines starts the chunky legs.

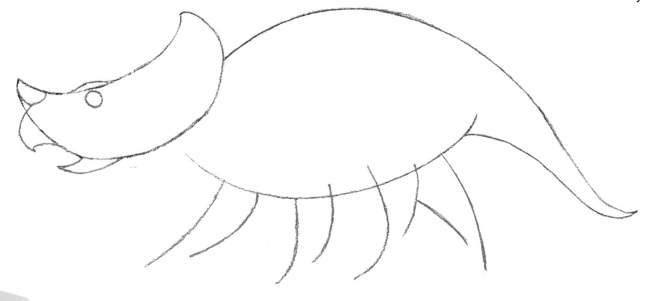

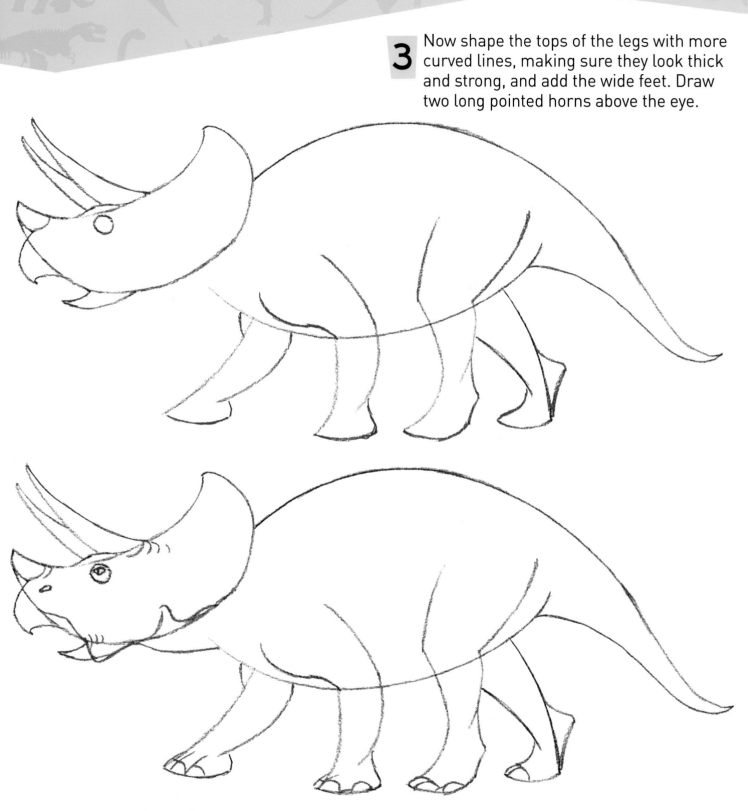

3 Now shape the tops of the legs with more curved lines, making sure they look thick and strong, and add the wide feet. Draw two long pointed horns above the eye.

4 Work on the Triceratops' neckline and bottom of the mouth. Add a nostril and wrinkle lines to give the dinosaur its character. Finish by drawing the toes.

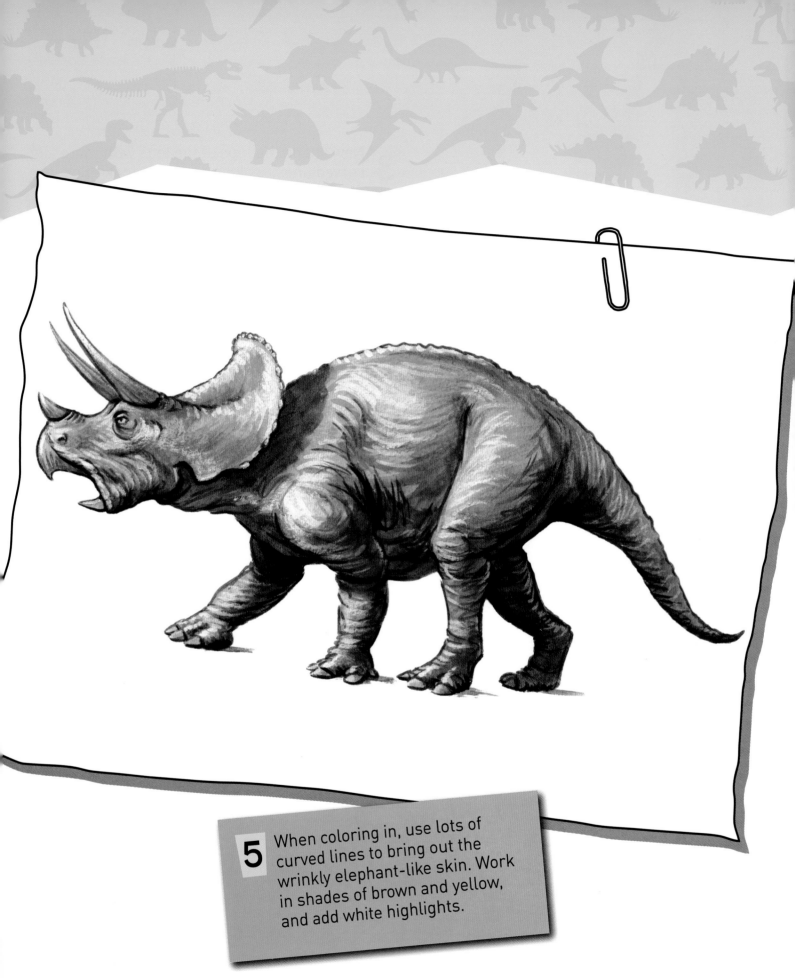

5 When coloring in, use lots of curved lines to bring out the wrinkly elephant-like skin. Work in shades of brown and yellow, and add white highlights.

Make your picture look even more professional with these artists' tips.

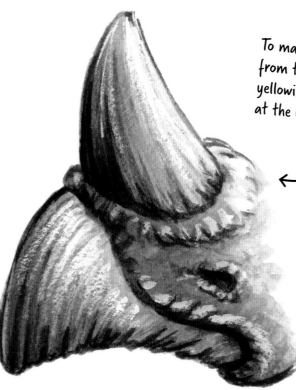

To make the horn on Triceratops' nose stand out from the rest of the body, work mainly in a yellowish-brown color. Then add dark shading at the bottom and white highlights at the top.

You can make Triceratops' skin look warty by drawing lots of small uneven shapes. Color the gaps a darker brown than the shapes.

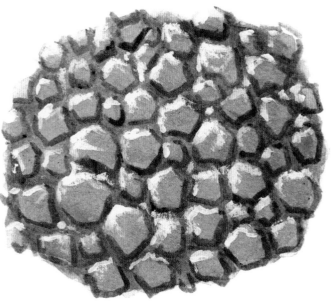

21

Ankylosaurus

Pick up your pencils and try drawing this Ankylosaurus with its swinging club tail. Ankylosaurus used its bony tail to defend itself from larger, meat-eating dinosaurs.

1 Start with a giant teardrop for the body and tail. Then draw a swooping curve to mark the edge of the back and neck armor. A triangle forms the head armor.

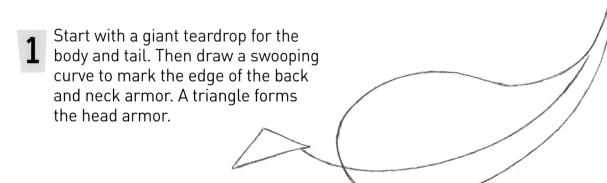

2 Next shape the head and neck, and add the face details. Give Ankylosaurus a friendly expression. Work on the legs and feet, and draw two circles for the club at the end of the tail.

3 A grid across the back will help you to position the bony armor. Draw pebble shapes on top of it, then erase the grid. Finally, add a cheek spike to the face and finish the toes.

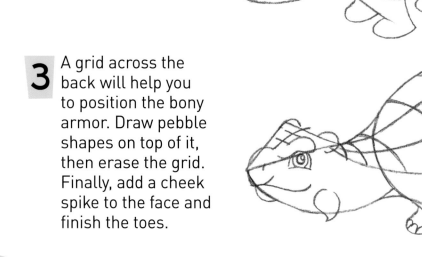

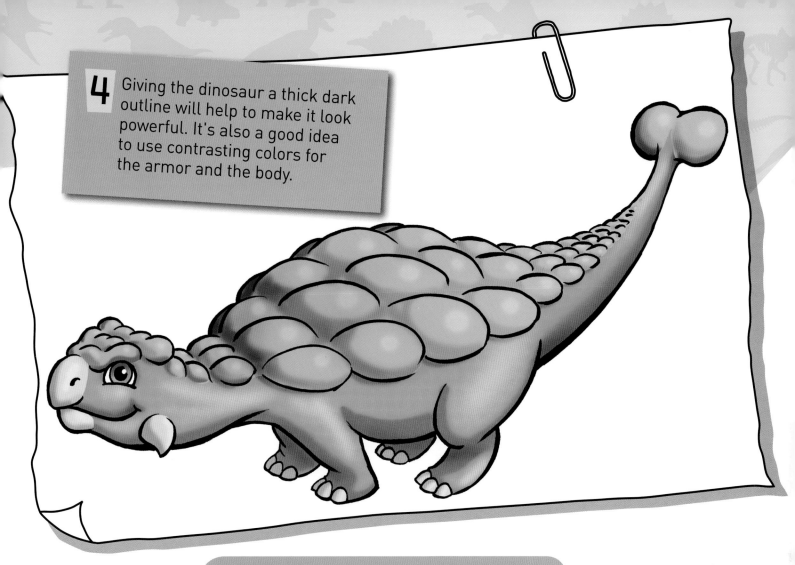

4 Giving the dinosaur a thick dark outline will help to make it look powerful. It's also a good idea to use contrasting colors for the armor and the body.

CARTOON CORNER

Want to show your Ankylosaurus in full swing? Then follow the steps below!

1

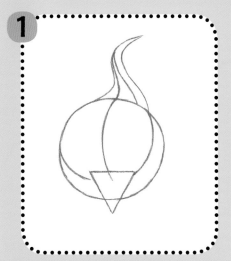

2

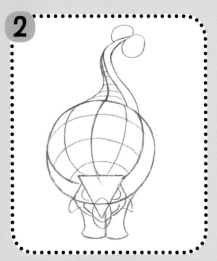

3

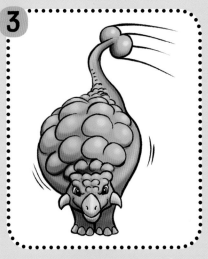

The dinosaur is facing you, so draw a circle for the body and a triangle pointing downward for the head armor. Copy the tail shape.

As before, add the grid for the body armor and the two circles for the tail. Then work on the face shape and the two wide front legs.

Color your dinosaur like the main picture or try something different. Add swishing lines to show the movement of the tail and body.

Archaeopteryx

Archaeopteryx was a small prehistoric flying creature that lived at the time of the dinosaurs. Work hard to capture its feathered birdlike wings and scaly dinosaur-like feet and claws.

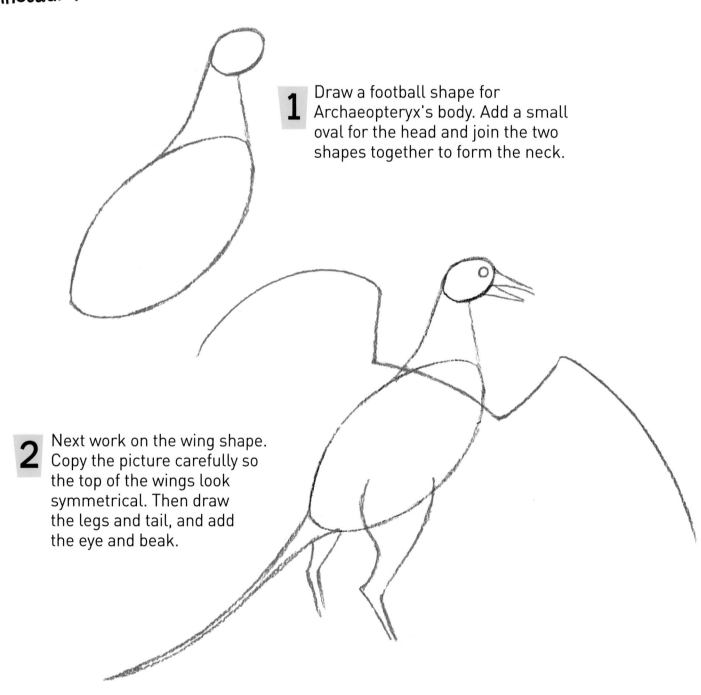

1 Draw a football shape for Archaeopteryx's body. Add a small oval for the head and join the two shapes together to form the neck.

2 Next work on the wing shape. Copy the picture carefully so the top of the wings look symmetrical. Then draw the legs and tail, and add the eye and beak.

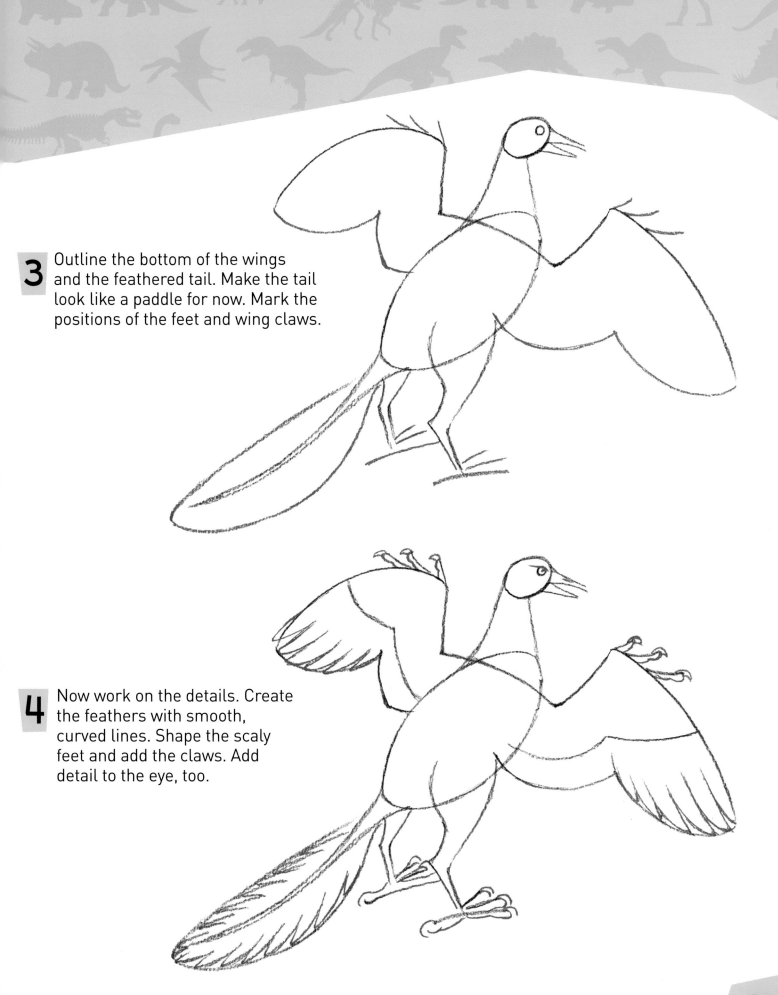

3 Outline the bottom of the wings and the feathered tail. Make the tail look like a paddle for now. Mark the positions of the feet and wing claws.

4 Now work on the details. Create the feathers with smooth, curved lines. Shape the scaly feet and add the claws. Add detail to the eye, too.

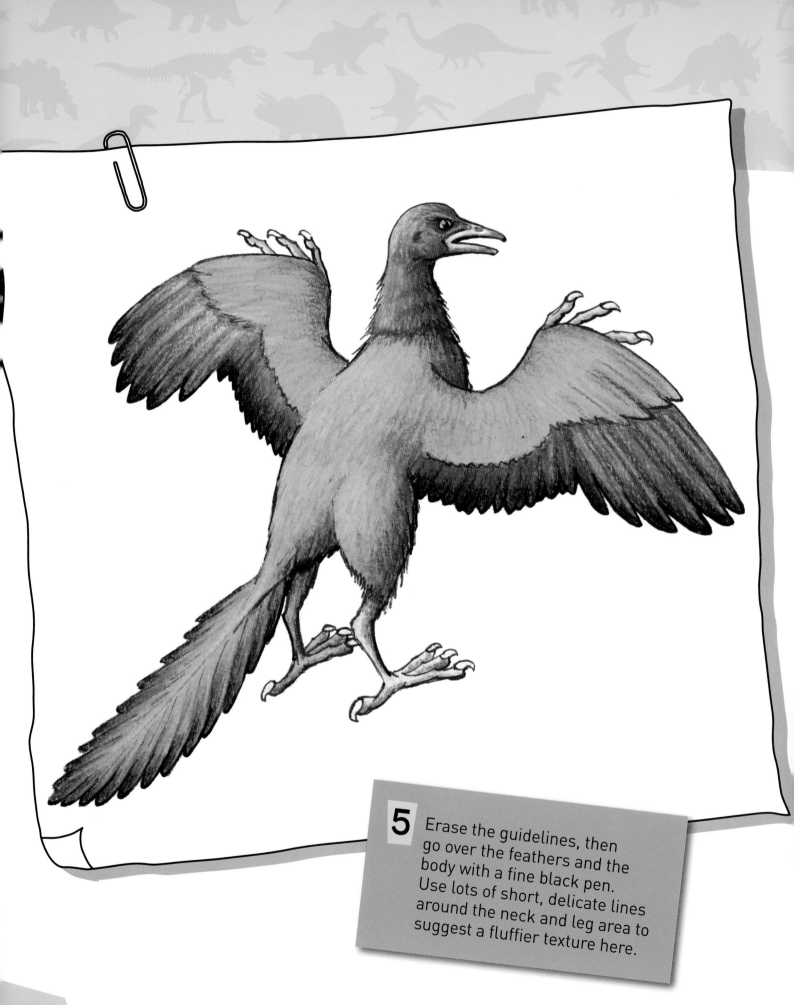

5 Erase the guidelines, then go over the feathers and the body with a fine black pen. Use lots of short, delicate lines around the neck and leg area to suggest a fluffier texture here.

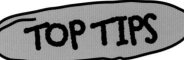

TOP TIPS

Feathers and scaly feet give Archaeopteryx its unique character. Here's how to draw and color them in close-up.

For the wings, lay down a watercolor base in green and blue first. Then on top, shade with a black pencil. This will create a feathery effect.

When drawing the feet, add oval shapes with a fine, black pen to create scales. Color the feet yellowish-brown.

Dimetrodon

With its huge sail, sharp teeth, and crocodile-like body, Dimetrodon was a fearsome land predator that lived about 280 million years ago. Get ready to draw this beast!

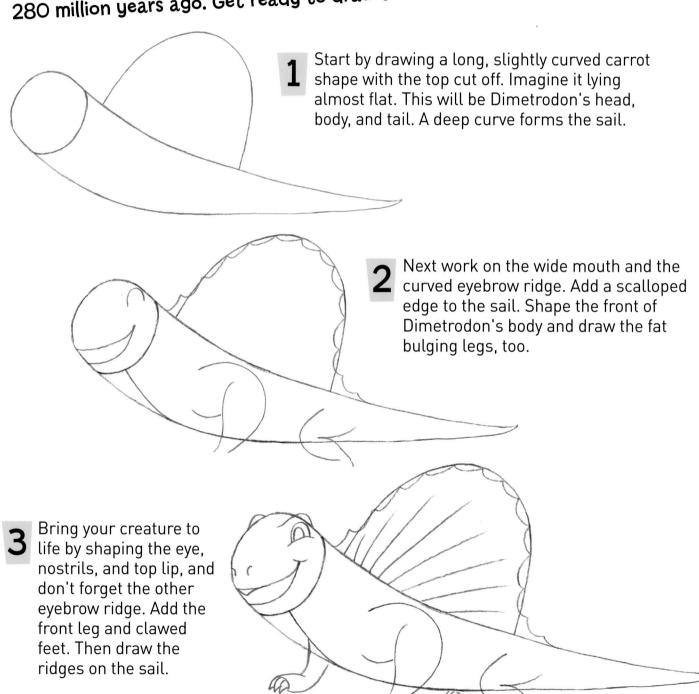

1 Start by drawing a long, slightly curved carrot shape with the top cut off. Imagine it lying almost flat. This will be Dimetrodon's head, body, and tail. A deep curve forms the sail.

2 Next work on the wide mouth and the curved eyebrow ridge. Add a scalloped edge to the sail. Shape the front of Dimetrodon's body and draw the fat bulging legs, too.

3 Bring your creature to life by shaping the eye, nostrils, and top lip, and don't forget the other eyebrow ridge. Add the front leg and clawed feet. Then draw the ridges on the sail.

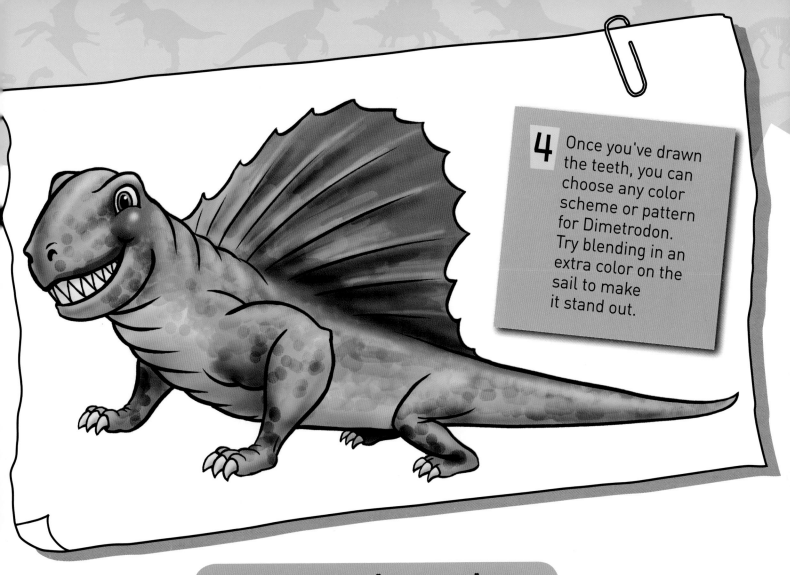

4 Once you've drawn the teeth, you can choose any color scheme or pattern for Dimetrodon. Try blending in an extra color on the sail to make it stand out.

CARTOON CORNER

There's more than one way to draw Dimetrodon!

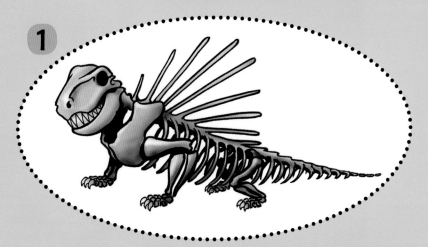

1

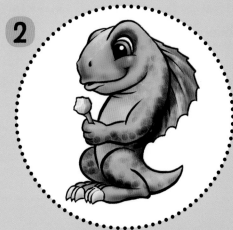

2

Draw its skeleton and you'll look like a real dinosaur expert. Make the ribcage long and add ridges to the tail. The skull should be large and solid while the bones in the sail need to be slender. Go over the outline with a fine, black pen, then color the picture grayish-brown.

Draw a baby Dimetrodon. Work with an S-shape and include a short tail and sail. Add a prop such as a bone to give the dinosaur personality.

PREHISTORIC PARK

Place your dinosaurs in a dramatic scene. We've used T. rex (pages 8–9), Velociraptor (pages 10–11), and Ankylosaurus (pages 22–23) for this picture but you could choose different dinosaurs, too.

1 Frame your picture with plants, trees, and leaves.

2 Hide the dinosaurs' feet and legs among the leaves to create different layers in the picture.

3 Notice how all the dinosaurs' eyes are looking toward the middle of the scene to give a focus.

4 Make the forest darker in the middle to create a sense of distance.

5 Items in the foreground appear larger than those farther back.

6 Vary the shapes of the leaves to make the picture more interesting.

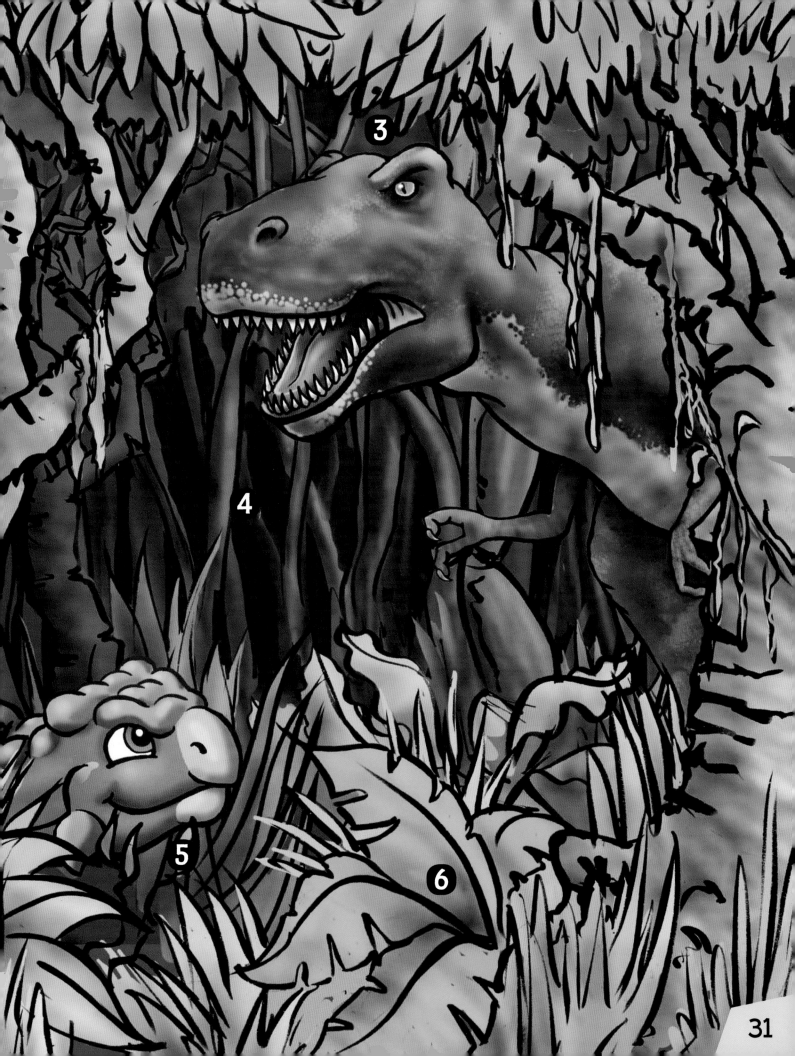

GLOSSARY

guideline (GYD-lyn) A pencil line to help you shape your drawing, which you then erase.

highlights (HY-lyts) White areas that help to make a drawing look solid and emphasize its shape.

mottled (MAH-tld) Covered with patches of different colors.

prehistoric (pree-his-TOR-ik) The period of time before events were written down.

reptile (REP-tyl) A cold-blooded animal that lays eggs and usually has scales or tough skin.

shade (SHAYD) To make an area of a picture darker.

spiral (SPY-rul) A curve winding around and around itself.

watercolors (WAH-ter-kuh-lerz) Water-based paints that are useful for blending colors.

INDEX

FURTHER READING

Beaumont, Steve. *Drawing T. Rex and Other Meat-Eating Dinosaurs.* Drawing Dinosaurs. New York: PowerKids Press, 2010.

Bergin, Mark. *Dinosaurs.* It's Fun to Draw. New York: Windmill Books, 2012.

Harpster, Steve. *Pencil, Paper, Draw!: Dinosaurs.* New York: Sterling Publishing, 2006.

Masiello, Ralph. *Ralph Masiello's Dinosaur Drawing Book.* Watertown, MA: Charlesbridge Publishing, 2005.

Miller, Steve. *Dinosaurs: How to Draw Thunder Lizards and Other Prehistoric Beasts.* New York: Watson-Guptill, 2008.

WEBSITES

For web resources related to the subject of this book, go to: **www.windmillbooks.com/weblinks** and select this book's title.